CONTENTS

Beautiful
WORD™
BIBLE STUDIES

REVELATION

extravagant hope

─── STUDY GUIDE · SIX SESSIONS ───

MARGARET FEINBERG

HarperChristian
Resources

Revelation Beautiful Word Bible Study

Copyright © 2021 by Margaret Feinberg

Requests for information should be addressed to:

HarperChristian Resources, *3900 Sparks Dr. SE, Grand Rapids, Michigan 49546*

ISBN 978-0-310-12238-8 (softcover)

ISBN 978-0-310-12239-5 (ebook)

Cover design: Ron Huizinga

Interior design: CrosslinCreative.net

First Printing January 2021 / Printed in the United States of America

WELCOME

REVELATION
extravagant hope

SOMETIMES the Bible can seem overwhelming. Where do you go for words of comfort when you're feeling overwhelmed, lost, or frustrated in life? What book of the Bible do you turn to for wisdom about the situation you find yourself in?

The Beautiful Word Bible Study series makes the Bible come alive in such a way that you know where to turn no matter where you find yourself in your spiritual journey.

Mention the book of Revelation, and you'll receive a spectrum of responses. Some will be intrigued, others fascinated, some perplexed, others hesitant, some nervous, others afraid. Toss around a mention of the number 666 or the beast, and some will wince while others grow wide-eyed.

Revelation falls into a genre known as apocalyptic literature. The Greek for *apocalypse* means "revelation" or "the unveiling of things not previously known." Just as you wouldn't pick up an electronics manual and read it like a novel or open a cookbook and read it like a history book,

Revelation has its own style. While genres like the Psalms, the Gospels, and epistles are much more instructive and straightforward, Revelation draws on layers of symbols, unusual visions, and strange imagery to give glimpses into the heavenly realm and the future.

John writes to the seven churches in Asia. In modern terms, this would be like sending a group text or email. Even though the churches are called out specifically (Revelation 2–3), everyone is reading the same content, learning from each other, and being called Christward.

With each passing page, we must resist the temptation to overemphasize or become dogmatic about interpretations or debatable topics that draw us away from what, or rather who, this book is all about: this is a revelation of Jesus Christ.

We must also practice generous grace toward those who read and interpret passages differently than us. Some read Revelation from a *futurist* perspective, seeing most of the chapters as being about what's to come. Others read from a *historicist* view, noting that much of the book focuses on what has happened over the centuries, and only a pinch is of what's still to come. Others take a *preterist* outlook, viewing much of what's described as happening only during the time John lived. Still others take an *idealist* method of interpretation, believing the teachings aren't tied to specific events but rather describe the ongoing battle between good and evil found in every age.

Regardless of your perspective, remember that followers of Jesus have hotly debated this book for thousands of years and will likely continue until Christ's return. Your goal isn't to win an argument. Your goal is to be conformed to the image of Jesus and discover the extravagant hope he has for you—in the past, in the present, and in the future.

With each passing page, we must resist the temptation to overemphasize or become dogmatic about interpretations or debatable topics that draw us away from what, or rather who, this book is all about: this is a revelation of Jesus Christ.

HOW TO USE THIS GUIDE

GROUP SIZE

The Beautiful Word *Revelation* video curriculum is designed to be experienced in a group setting such as a Bible study, small group, or during a weekend retreat. After watching each video session, you and the members of your group will participate in a time of discussion and reflection on what you're learning. If you have a larger group (more than twelve people), consider breaking up into smaller groups during the discussion time.

MATERIALS NEEDED

Each participant should have their own study guide, which includes video outline notes, group discussion questions, a personal study section, Beautiful Word coloring pages, and Scripture memory cards to deepen learning between sessions.

TIMING

The timing notations—for example, 20 minutes—indicate the actual length of the video segments and the suggested times for each activity or discussion. Within your allotted time, you may not get to all the discussion questions. Remember that the *quantity* of questions addressed isn't as important as the *quality* of the discussion.

FACILITATION

Each group should appoint a facilitator who is responsible for starting the video and keeping track of time during the activities and discussion. Facilitators may also read questions aloud, monitor discussions, prompt participants to respond, and ensure that everyone has the opportunity to participate.

OPENING GROUP ACTIVITY

Depending on the amount of time you have to meet and the resources available, you'll want to begin the session with the group activity. You will find these activities on the group page that begins each session. The interactive icebreaker is designed to be a catalyst for group engagement and help participants move toward the ideas explored in the video teaching. The leader will want to read ahead to the following week's activity to see what's needed and how participants may be able to contribute by bringing supplies or refreshments.

TEMPTED
TO GIVE UP ON
GOD?

REVELATION

OPENING GROUP ACTIVITY [10-15 MINUTES]

What you'll need:

▶ Sheet of blank paper for each person

▶ Pens, markers, and/or watercolors

1. Each participant is invited to use the paper and drawing/writing tools to create either a picture of what's described in Revelation 1:12–16 or a list (words or images) of symbols included in the description.

2. Discuss the following questions:

 • When you think of the book of Revelation, what comes to mind?

 • Describe your first exposure to the book of Revelation and whether that was a positive, negative, or neutral experience.

 • What element of your drawing stood out to you the most? Why?

SESSION ONE VIDEO [24 MINUTES]

NOTES: *As you watch, take notes on anything that stands out to you.*

 What if, through the book of Revelation, God is saving the best for last?

 John was in a dark place. His fledgling churches were struggling. Fellow disciples had died brutal, barbaric deaths. He was surrounded by uncertainty about his own future and the future of the faithful.

 Apocalypse means "unveiling" or "uncovering."

What made you reflect? What

What surprised you?

What caught your attention?

➤ In our personal setbacks and suffering, there's always a temptation to retreat, to pull back from God, at the precise moment we need him most.

➤ The seven golden lampstands represent the seven churches. Gold represents the purifying work Christ does in and through the church. The lampstands remind us we are called to stand and shine bright like a city on a hill.

➤ As a soldier's uniform tells you something about that person's role, these garments reveal Christ as priest.

➤ The white wool and white snow declares there's nothing that Christ cannot forgive.

➤ Feet of glowing bronze reveal that Jesus is flawless.

➤ Jesus illuminates the cosmos, and he illuminates our lives.

➤ Jesus is giving you a golden invitation to a fresh revelation of who he is and how he's going to see you through.

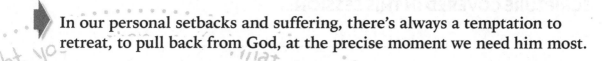

GROUP DISCUSSION QUESTIONS (30–45 MINUTES)

1. What are some of the hang-ups, fears, or bad experiences with Revelation you need to let go of to get the most out of this study?

2. What can you do to ground yourself (as an individual and as a group) in the truth that no matter what you read in Revelation, it's all about Jesus? Write down some ground rules and ideas in the space below:

3. Margaret teaches,

> "Revelation is a survival guide for the suffering, a book of promises for the persecuted, a banner of hope for the beaten down."

 In what area of your life are you most beaten down and ready to give up right now? Where do you most need to experience the presence and power of Jesus?

4. Read Revelation 1:4–8. Which of the names or titles of Jesus is the most meaningful to you? Why? Underline or write down the one you would most like to experience more of right now?

5. Margaret teaches,

> "John decides to turn and see—to engage with God rather than retreat—and that changes everything."

When it comes to encountering God, when are you most likely to engage? When are you most likely to retreat?

6. Read Revelation 1:12–16. What aspect of this description of Jesus is most meaningful to you now? Why?

CLOSE IN PRAYER

Consider the following prompts as you pray together for:

▶ The ability to let go of preconceived ideas about Revelation to discover the power of Christ and to know him in new ways

▶ An open heart to receive the hopeful message of God without fear or hesitation

▶ Opportunities this week to share the hope of Jesus with others

PREPARATION
To prepare for the next group session:

1. Read Revelation 1–3.

2. Tackle the three days of the Session One Personal Study.

3. Memorize this week's passage using the Beautiful Word Scripture memory coloring page. As a bonus, look up the Scripture memory passage in different translations and take note of the variations.

4. If you've agreed to bring something for the next session's Opening Group Activity, get it ready.

"I am the Alpha and the Omega," says the Lord God, "who is, and who was, and who is to come, the Almighty."

—Revelation 1:8

SESSION
1

PERSONAL
STUDY TIME

DIGGING INTO THE

Beautiful
WORD™

BIBLE STUDIES

REVELATION

TEMPTED TO GIVE UP ON GOD?

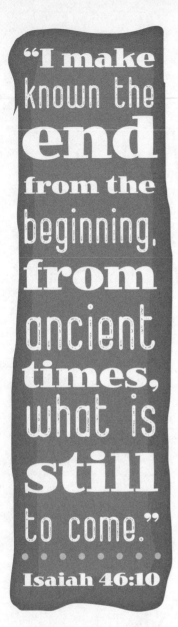

"I make known the end from the beginning, from ancient times, what is still to come."

Isaiah 46:10

DAY 1
REVELATION 1

John began his career as a fisherman in the Sea of Galilee alongside his brother James. He left everything to follow Christ. John became one of Jesus' closest friends (John 21:20), entrusted to care for Jesus' mother, Mary (John 19:25–27). He also penned the Gospel of John, and 1, 2, and 3 John.

1. Read Revelation 1:1–2. Why was the revelation given according to this passage? What is John's revelation?

2. Read Revelation 1:3. This is the only book in the Bible that includes a promise of blessing for all who read it. What blessing would you like to receive from reading Revelation? Write down your desire as a prayer that God will answer as you study.

John pens his letter to seven real churches throughout the region. He greets them with "grace and peace," which is a common welcome throughout many of the epistles.

3. Read Revelation 1:4–8. Fill in the chart below recording the names of God, Jesus, and us in this passage. Which is the most meaningful to you in this moment of life? Why?

NAMES OF GOD	NAMES OF CHRIST	WE ARE DESCRIBED AS . . .

4. Read Revelation 1:9–11. Make a list of all the attributes of John you can glean from this passage. What kind of person might he have been? What had his life been like previous to this passage?

5. Which one helps you most to identify with John as a Christian brother? Why?

John mentions the **sevenfold Spirit** before God's throne (Revelation 1:4). This likely refers to **the fullness of the presence of the Holy Spirit**. **Revelation** is sometimes called the **Book of Sevens** because there are so many—seven spirits, seven churches, seven seals, seven trumpets, seven thunders, seven signs, seven bowls, seven blessings, seven last things, and more. Seven often represents divine perfection and completeness.

6. While some of the images found in Revelation may sound strange, they're often deeply rooted in Scripture. Reflecting on the symbols enumerated in Revelation 1:12–16, look up the following passages and fill in the chart below. What surprises you most?

ELEMENT OF JOHN'S VISION	SCRIPTURE	WHAT THE OLD TESTAMENT REVEALS ABOUT JOHN'S WORDS IN REVELATION 1:12–16
Seven lampstands	Exodus 25:31–40	
Robe	Exodus 28:4 Isaiah 6:1	
White hair	Daniel 7:9	
Feet like bronze	Ezekiel 1:27–28	
Voice of rushing waters	Ezekiel 1:24	
Sharp, double-edged sword	Psalm 149:6 Hebrews 4:12	
Face like the shining sun	Exodus 34:28–30	

7. Read Revelation 1:17–19. How does John respond to seeing Jesus? How does Jesus' response to John demonstrate his care and compassion toward John and toward you?

8. Read Revelation 1:19–20. What do the seven stars represent? What do the seven lampstands represent? What fills you with the most hope from this chapter?

DAY 2
REVELATION 2

Most of the words Jesus speaks are found in the Gospels, but in Revelation we find more rich teachings of Christ. Remember, this is a revelation of Jesus!

John dictates the words of Christ to seven churches. These believers met in seven cities clustered in modern-day Turkey. The words remain timeless because we can still find churches like this today. And we can find places in our hearts where these messages ring true of us individually, too, not just in our local churches.

The church at Ephesus, to whom the first letter is addressed, was located in a prosperous trade center on the coast. It was known as Asia's Supreme Metropolis. The city boasted one of the wonders of the ancient world, a temple for the "bee" goddess known as

Artemis or Diana. Thousands of priests and priestesses worshiped and practiced cult prostitution there.

The letters to the churches follow a particular pattern: who the letter is written to, description of Christ, commendation, correction, counsel or direction, and a challenge.

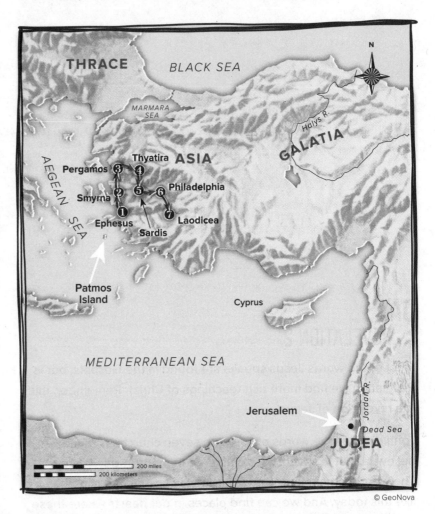

© GeoNova

1. Read Revelation 2:1–7 and fill in the chart on the next page. Then circle the statements that are also true of you. (Note: Some spaces in this chart may need to be left blank because no commendation or correction is given.)

REVELATION 2:1–7

Church Addressee	
Revelation of Jesus Christ (self-identification)	
Commendation	
Correction	
Counsel/Directive	
Clarion Call, Challenge, and Reward	
Reflecting on this chart, what is Christ calling you toward?	

2. How has your love for Christ changed since you became a believer? What have you found that reignites your love for Christ? What do you need to repent, remember, and do?

Smyrna was a well-developed and beautiful city, containing temples to Zeus, Apollo, Aphrodite, and others. It was also the thriving center of emperor worship.

3. Read Revelation 2:8–11. Fill in the chart below, then circle the statements that are also true of you. (Note: Some spaces in this chart may need to be left blank because no commendation or correction is given.)

REVELATION 2:8–11	
Church Addressee	
Revelation of Jesus Christ (self-identification)	
Commendation	
Correction	
Counsel/Directive	
Clarion Call, Challenge, and Reward	
Reflecting on this chart, what is Christ calling you toward?	

Jesus promises the crown of life to those who stand firm in their faith.

The Bible speaks of many crowns given to overcomers, including the imperishable crown (1 Corinthians 9:24–27), the crown of rejoicing (1 Thessalonians 2:19–20), the crown of life (James 1:12), the crown of righteousness (2 Timothy 4:8), and the crown of glory (1 Peter 5:2–4).

4. Describe a time of personal suffering, loss, or pain in which you discovered Christ's faithfulness. How does this message to Smyrna inspire you to suffer strong?

Like Smyrna, Pergamum was a center for worshiping pagan gods and the emperor. When Jesus calls Pergamum "the city where Satan has his throne" (v. 13), he is probably referring to the city's temple built specifically for worshiping Caesar and to its altars to Zeus and Asclepius, the snake-god of healing. Pergamum was also unique in that Rome had given it permission to practice capital punishment, which Jesus may be alluding to when he mentions "the sharp two-edged sword" (v. 12).

Manna refers to the food God provided for the Israelites as they wandered in the wilderness and ran out of food (Exodus 16). Jesus reveals himself as our hidden manna, reminding us of his grace and goodness when we find ourselves in the wilderness.

In this section, you'll find a reference to Balaam. He was an Old Testament prophet who took money from an enemy king, Balak, to pronounce a curse on Israel. He devised a deceptive plan that led Israelite men to worship Baal (Numbers 22–31). Eventually, the children of Israel killed Balaam and Balak with a sword. Jesus tells those in Pergamum that something similar has happened to them. They've been led astray, and he fights for them with the spiritual sword of Scripture.

5. Read Revelation 2:12–17. Fill in the chart below, then circle the statements that are also true of you. (Note: Some spaces in this chart may need to be left blank because no commendation or correction is given.)

REVELATION 2:12–17	
Church Addressee	
Revelation of Jesus Christ (self-identification)	
Commendation	
Correction	
Counsel/Directive	
Clarion Call, Challenge, and Reward	
Reflecting on this chart, what is Christ calling you toward?	

6. What are three temptations you wrestle with that can cause you to compromise your faith? What strategies do you have to overcome these temptations (1 Corinthians 10:13)?

Located inland, Thyatira was a smaller city famous for distributing clothes and cloth dipped in purple dye. The letter written to Thyatira is the longest and one of the most challenging letters written to the seven churches.

7. Read Revelation 2:18–29. Fill in the chart below, then circle the statements that are also true of you. (Note: Some spaces in this chart may need to be left blank because no commendation or correction is given.)

REVELATION 2:18–29	
Church Addressee	
Revelation of Jesus Christ (self-identification)	
Commendation	
Correction	
Counsel/Directive	
Clarion Call, Challenge, and Reward	
Reflecting on this chart, what is Christ calling you toward?	

JEZEBEL, THE WIFE OF KING AHAB IN THE OLD TESTAMENT, WAS A PRIESTESS IN A PAGAN TEMPLE WHICH TAUGHT HERESIES, INCLUDING THE EATING OF FOOD SACRIFICED TO IDOLS AND TEMPLE FORNICATION.

(1 Kings 16:31–33; 2 Kings 9:22)

White stones were inscribed and used as invitations to banquets. The new name may refer to receiving a white stone with a secret name of Jesus that reveals our intimate relationship with him or the new name Christ has for us (2:17).

8. What are three attitudes or actions you're still holding onto that don't align with the purity, single focus, and deep love that Christ calls you to throughout these letters to the churches? In the space below, write a prayer asking for forgiveness and freedom.

DAY 3
REVELATION 3

We continue our study of the letters to the seven churches with Sardis. Built on a hill, this fortified city was strategic to Rome's military. When Jesus mentions clothing in verses 4 and 5, he may be alluding to the city's famous and flourishing wool industry.

In antiquity, the name of each citizen was recorded in a register. Once the person died or was convicted of a serious crime, their name was marked out of the book.

Jesus promises that our name can never be blotted out from the book of life, because nothing—including death—can separate us from the love of God. See Exodus 32:32–33; Isaiah 4:3; and Romans 8:38.

1. Read Revelation 3:1–6. Fill in the chart below. Remember to pay attention to lines which may need to be left blank because no commendation or correction is given. Then circle the statements that are also true of you.

REVELATION 3:1–6	
Church Addressee	
Revelation of Jesus Christ (self-identification)	
Commendation	
Correction	
Counsel/Directive	
Clarion Call, Challenge, and Reward	
Reflecting on this chart, what is Christ calling you toward?	

2. In what area of your life do you sense the Holy Spirit calling you to "wake up" and "change into clean clothes"?

3. Read Revelation 3:7–13. Philadelphia, meaning "city of brotherly love," was a strong fortress city. Located in an area prone to earthquakes, it was prosperous because of its textile and leather industries as well as nearby vineyards.

Fill in the chart below. Pay attention to entries which may need to be left blank because no commendation or correction is given. Then circle the statements that are also true of you. (Note: Some spaces in this chart may need to be left blank because no commendation or correction is given.)

REVELATION 3:7–13	
Church Addressee	
Revelation of Jesus Christ (self-identification)	
Commendation	
Correction	
Counsel/Directive	
Clarion Call, Challenge, and Reward	
Reflecting on this chart, what is Christ calling you toward?	

4. Reflecting on this passage, what is the greatest word of encouragement to you right now?

Laodicea was so wealthy that after it was destroyed by the great earthquake of 60 AD, the residents refused rebuilding help from neighboring regions. The Laodiceans did it all themselves. Famous for its school of medicine, Laodicea produced a special ointment believed to cure eye and ear defects.

5. Read Revelation 3:14–22. Fill in the chart below. Again, pay attention to lines which may need to be left blank because no commendation or correction is given. Then circle the statements that are also true of you.

REVELATION 3:14–22	
Church Addressee	
Revelation of Jesus Christ (self-identification)	
Commendation	
Correction	
Counsel/Directive	
Clarion Call, Challenge, and Reward	
Reflecting on this chart, what is Christ calling you toward?	

6. In your life, how have you seen material prosperity lead to spiritual poverty? In what ways is your spiritual reputation outpacing your spiritual reality?

7. Review your charts of the seven letters to the churches. Which commendations from Christ stand out to you personally? Which corrections from Christ stand out to you personally?

8. Reflecting on the promises and rewards from the seven letters, which ones give you the most hope right now? Why? Which ones encourage you to never give up on Christ, because he's never given up on you?

As you reflect on your personal study of **Revelation 1–3,** what are the **beautiful words** that the **Holy Spirit** has been highlighting to you through this time? Write or draw them in the space below.

SESSION
2

HAVE YOU
LOST
PERSPECTIVE?

REVELATION

OPENING GROUP ACTIVITY (10-15 MINUTES)

What you'll need:

▶ Sheet of blank paper for each person

▶ Pens, markers, and/or watercolors

1. Invite participants to draw a big rainbow at the top of the paper. Read Revelation 4:2–6. Below the rainbow, write a list of everything and everyone present in this amazing scene.

2. Discuss the following questions:

 ● Of all those present in this scene, who would you most want to be? Why?

 ● What do you think would be your first response emotionally and physically to standing in the throne room?

SESSION TWO VIDEO (23 MINUTES)

NOTES: *As you watch, take notes on anything that stands out to you.*

▶ The two telltale signs that you've lost perspective: Overvaluing what's less important and undervaluing what's truly important.

▶ The throne speaks to God's authority and power, his supremacy and sufficiency as the centerpiece of all.

▶ Some believe the two sets of 12 refer to the 12 Hebrew tribes and the 12 Christian apostles brought together—Israel and the Church unified.

What made you reflect? What surprised you? What caught your attention?

► Jesus always has perspective, even when you don't.

► A holy perspective is a hopeful perspective, and a hopeful perspective is a holy perspective.

► A heavenly perspective that right-sizes earthly concerns.

► Pray yourself into this passage.

► Join the holy chorus of worship.

REVELATION 4

GROUP DISCUSSION QUESTIONS [30-45 MINUTES]

1. Margaret says,

"When we lose perspective, we do one of two things: we overvalue what's less important or we undervalue what's truly important."

 What's one thing in your life that you've been overvaluing? What's one thing in your life that you've been undervaluing? What's the long-term cost of losing perspective? What changes will you make to value these things rightly?

2. Reflecting on Revelation 4, which of the images in the throne room mean the most to you right now? Explain. How does focusing on the incredible scene throughout this chapter shift the way you see your own struggles? What does this chapter reveal to you about God?

3. What three things tend to prevent you from bringing all that you have, all that you are before Jesus?

4. You and your fellow participants are invited to take a few moments of silence to pray yourselves into Revelation 4 while the group facilitator slowly reads it aloud. Prayerfully consider what Jesus is asking you to let go of and lay hold of through the Holy Spirit. Then, as a group, discuss what came to mind through this simple practice.

5. What song of praise or worship has been helping to carry you through whatever season you are currently in?

6. On a scale of 1 to 10, how important is praise or worship to you? Explain. Compare or contrast this to the importance of worship described in John's vision of the throne room.

CLOSE IN PRAYER

Consider the following prompts as you pray together for:

▶ Courage to respond to the invitation to "Come up here"

▶ Revelation of where your perspective needs to be re-centered on Christ

▶ The determination to join the holy chorus of worship each day

PREPARATION
To prepare for the next group session:

1. Read Revelation 4–6.

2. Tackle the three days of Session Two Personal Study.

3. Memorize this week's passage using the Beautiful Word Scripture memory coloring page. As a bonus, look up the Scripture memory passage in different translations and take note of the variations.

4. If you've agreed to bring something for the next session's Opening Group Activity, get it ready.

"You are worthy, our Lord and God, to receive glory and honor and power, for you created all things, and by your will they were created, and have their being."

—Revelation 4:11

SESSION
2

PERSONAL
STUDY TIME

DIGGING INTO THE

Beautiful
WORD™

BIBLE STUDIES

REVELATION

HAVE YOU LOST PERSPECTIVE?

"[The Lord] put a new song in my mouth, a hymn of praise to our God."

—Psalm 40:3

DAY 1
REVELATION 4

Following the seven letters, John is invited to "come up here" to see a heavenly perspective much like an Old Testament prophet's experience in Ezekiel 1:1. John discovers that everything—past, present, and future—rests under God's authority.

1. Read Revelation 4:1–8 and Ezekiel 1:4–14, 26–28. What parallels do you see between the two passages? How do they compare and contrast?

The angels, elders, and four living creatures are supernatural beings who worship God and fulfill God's purposes. The flashes of lightning and thunderous rumblings speak of God's presence and power, reminiscent of the sounds Moses heard as he prepared to receive the Ten Commandments on Mount Sinai (Exodus 19:16).

2. Read Revelation 4:9–11. What is the heavenly response to God? What does it look like for you to cast yourself at the feet of God?

The repetition of "Holy, holy, holy" reminds us of the prophet Isaiah's vision (Isaiah 6:3) and emphasizes what those in God's presence celebrate and sense.

3. Reflecting on this passage, what characteristics of God do the creatures and elders mention as they worship?

4. What characteristics of God do you tend to focus on in your worship?

5. The throne mentioned in this chapter isn't a type of furniture as much as it symbolizes the rule and authority of God, and everything in this chapter centers on it. How many times does the word *throne* appear in Revelation 4?

Enter the total number here: ...

Why is emphasis on the throne so important in this scene and in your life?

Revelation 4:8 and 11 contain the first two of many **HYMNS** sung throughout this book. Take a moment to say and **SING THESE** hymns aloud.

6. What connections do you see between each of the following passages and Revelation 4?

 1 Kings 22:19 =

 Psalm 47:8 =

 Isaiah 6:1 =

 Isaiah 66:1 =

 Daniel 7:9 =

7. How does seeing the connections between Revelation 4 and passages from the Old Testament enrich the way you read and study?

8. How does this chapter demonstrate that Jesus' perspective is always the best perspective?

DAY 2
REVELATION 5

The celebration of God in chapter four transitions to a celebration of Jesus in chapter five. John sees a sealed scroll in God's right hand. Romans sealed their scrolls six to seven times with soft wax over the edges of the parchment to ensure no one tampered with the contents without authorization. No angel, no demon, no human has the right or righteousness to open this holy scroll—only Jesus, the Lion of the tribe of Judah (Genesis 49:8–10), the Root of David (Isaiah 11:1–10), the ultimate conqueror of death (1 Corinthians 15:55–57).

1. Read Revelation 5:1–10. How does this worship scene compare and contrast to the one in Revelation 4?

2. What stands out to you most about this scene? Why is that meaningful to you right now?

3. Why is Jesus worthy to take the scroll? What does this reveal about his character and intention toward you?

In the Bible, **horns** symbolize **power.** The number **seven** symbolizes **completeness.**

Seven horns represent complete power. Seven eyes symbolize complete perception of all things (verse 6).

MILLIONS OF ANGELS MINISTERED TO HIM; MANY MILLIONS STOOD TO ATTEND HIM. THEN THE COURT BEGAN ITS SESSION, AND THE BOOKS WERE OPENED.

Daniel 7:10

The scene of a slain lamb that's alive may sound strange until you remember that whenever an animal was brought to the temple for sacrifice in the Old Testament, the person would place a hand on the sheep, confess sins, and then with a swift motion, slice the animal's throat. Through this symbolic act, the animal died in place of the guilty human. John sees this Lamb's cut throat just like the ancient sacrificial symbol, but the Lamb is not dead, but fully alive, representing the one who was the ultimate sacrifice for sin: Jesus. This is a portrait of extravagant hope for us.

4. Revelation 5:9 says those in God's presence are from every tribe, tongue, people, and nation. What types of people do you tend to look down on or consider less worthy of God's redemption, even subconsciously? When you first read Revelation's description of this worship scene, did you imagine those people present?

5. How does this passage challenge you to reconsider personal areas of racism, exceptionalism, or judgmentalism?

All of heaven offers praise to God. The words of their worship are important, because they reveal the qualities of God as well as the acknowledgment of all he deserves.

6. Read Revelation 5:11–14. Fill in the chart below. Then circle the ones that are easy for you to acknowledge through worship. Underline those that are more difficult for you to acknowledge through worship. Ask God to help you worship him in his fullness.

LIST THE SEVEN QUALITIES INTRINSIC TO GOD (REVELATION 5:12)	LIST THE FOUR ACKNOWLEDGMENTS OF ALL GOD DESERVES (REVELATION 5:13)
1.	1.
2.	2.
3.	3.
4.	4.
5.	
6.	
7.	

John's emotional response of weeping reminds us of what we cannot do on our own. Without Jesus, we cannot experience the joy of his redemption and the forgiveness of sins.

EACH OF THE **FOUR RIDERS** ARE CALLED FORTH BY THE **HEAVENLY CREATURES** USING TERMS THAT WERE **COMMON** WHEN STADIUM ANNOUNCERS WOULD SUMMON THE CHARIOT DRIVERS IN ROMAN ARENAS.

7. How do these scenes in Revelation 5 comfort you and challenge you in your relationship with Christ?

8. How do these powerful glimpses of heaven challenge you to live and worship differently here on earth? The word *worthy* is used several times. Are you living worthy of Jesus (see 1 Thessalonians 2:11–12)?

DAY 3
REVELATION 6

After grounding us in a heavenly perspective on the one who was, and is, and is to come, the opening of the seals transitions us to scenes of events on earth. The opening of the scrolls by Jesus reveals God's plan for the completion of the mystery of all things and all people, including both the overcomers and those who oppose God. No matter how you interpret this passage, remember that first and foremost, this is a revelation of Jesus Christ and the extravagant hope we have in him.

A quart of wheat was the ration for a single day for a Roman soldier.

1. Read Revelation 6:1–8 and fill in the chart on the next page. For a creative element, use colored pencils or markers that match the horse to fill in each entry.

SCRIPTURE	SEAL NUMBER	COLOR/ DESCRIPTION OF HORSE	POWER GIVEN TO RIDER	INTERESTING NOTE
Revelation 6:1–2				The passage mentions a bow, but no arrows, possibly suggesting the rider doesn't use war, but other methods.
Revelation 6:3–4				The large sword may represent the large number of those killed.
Revelation 6:5–6				Wheat, oil, and wine were basic food staples in the Middle East, used to cook. Wine was used to purify water.
Revelation 6:7–8				*Pale* in Greek is *chloros,* meaning "yellowish green, denoting sickness and cadaverous colors."

The dark imagery may feel overwhelming, but it's important to remember that none of this happens outside of God's power or permission. One surprising place I've found comfort is by taking a step back and remembering that God made the majestic horse.

2. Read Job 39:19–25. How does this most complete review of horses in the Bible reveal God's authority and power?

After the four horses ride, the fifth seal reveals the saints who have died, calling for justice. This sudden shift reminds us that even as the hardships unfold, God remains laser-focused on his faithful followers. These saints may include those who have so faithfully followed Christ that they have given up their physical lives, as well as those who have spiritually offered up their lives to Christ wholly and completely.

3. In what ways have you offered up your life wholly and completely to Christ? In what areas are you still holding back?

4. Read Revelation 6:9–17 and fill in the chart below.

SCRIPTURE	SEAL NUMBER	WORDS SPOKEN OR CRIED OUT	RESULT OF SEAL BEING OPENED	INTERESTING NOTE
Revelation 6:9–11				The altar may refer to the golden altar in the tabernacle (Exodus 30:1–10) or the altar of incense representing the prayers of the saints (Rev 5:8; 8:3–4).
Revelation 6:12–14				These events speak of the final days of the Lord spoken of throughout the Bible (Isaiah 2:10; Jeremiah 4:29; Ezekiel 32:7–8).
Revelation 8:1–5				God's judgment on those who refuse to repent crosses every socioeconomic and status line.

5. What does God do to get your attention and display his power in your life?

6. Describe a time when you faced great trial or tribulation in your life. How did God reveal his goodness and faithfulness to you during that time?

7. Read Matthew 24:6–29. What parallels do you see between Revelation 6 and Jesus' words?

8. Read Matthew 24:30–35. What hope and encouragement do you find in Jesus' encouragement that though the temporal will pass away, his love and promises never will?

As you reflect on your personal study of Revelation 4–6, what are the beautiful words that the Holy Spirit has been highlighting to you through this time? Write or draw them in the space below.

SESSION 3

WHEN
LIFE'S NOT
FAIR

REVELATION

OPENING GROUP ACTIVITY (10-15 MINUTES)

What you'll need:

▶ Sheet of blank paper for each person

▶ Pens, markers, and/or watercolors

1. Each participant is invited to use the paper and drawing/writing tools to create either a picture of what's described in Revelation 6:2–8 or a list (words or images) of symbols included in the description.

2. Discuss the following questions:

 ● What comes to mind when someone mentions the four horses of the apocalypse?

 ● Why do you think the imagery is scary for some people?

 ● Which of the four horses is the worst to you? Explain.

SESSION THREE VIDEO (24 MINUTES)

NOTES: *As you watch, take notes on anything that stands out to you.*

 The book of Revelation is written to everyone who has asked, "Lord, how long . . . ?

 Together, these horses reveal the patterns through which hell is released on earth: conquest, violence, oppression, and death.

 This throne room is a heavenly temple. Under the altar, we see faithful saints who resist evil and oppression in all its forms.

 The cry of the saints throughout history is, "It's not fair!" to which God answers, "I'm not finished!"

 God answers the cry of the saints through a global disruption that upends the earthly systems used to spread evil. It's no longer the oppressor and the oppressed. The oppressor now knows what it's like to be oppressed.

 No matter how bad the score looks mid-game, Christ wins in the end. And you are Jesus' winning strategy.

 Of the seven seals, the greatest seal of all is the one on you. In Christ, you are secured and identified as God's own.

 Life is not fair, but Jesus is not finished. And He wants to do his greatest work through you.

 When you love God and love others, when you forgive the unforgiveable, and when you turn the other cheek, you take evil out of circulation.

GROUP DISCUSSION QUESTIONS (30–45 MINUTES)

1. Describe a time when life hasn't been fair for you. How has Jesus helped you to stand firm and overcome?

2. Read Revelation 6:10. In what area of your life are you asking God, "How long?" What comfort do you find in knowing that no matter how bad the score looks mid-game, Christ wins in the end?

3. Margaret teaches,

"Of all the seven seals, do you know what I believe is the greatest seal of all? The seal on you. You have been marked, set apart, claimed as God's own."

What in your life makes you second-guess, doubt, or question that you've been sealed by God? What comfort do you find in knowing you're sealed by God for this life and for eternity?

4. Describe a time recently when someone, through their kindness, patience, or grace, took evil out of circulation for you.

5. Describe a time in the past when you helped take evil out of circulation. Where is Jesus asking you to take evil out of circulation right now? How is Jesus calling you to rise up in faith and action?

6. Read Revelation 7:15–17. Which of the promises in this passage are you looking forward to the most? Why?

CLOSE IN PRAYER

Consider the following prompts as you pray together for:

▶ Courage to trust God when life isn't fair

▶ Strength to persevere when God's timetable isn't our own

▶ Opportunities and courage to take evil out of circulation

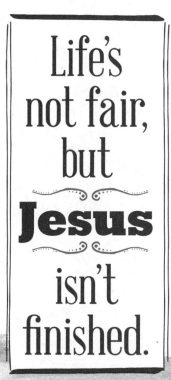

PREPARATION
To prepare for the next group session:

1. Read Revelation 7–11.

2. Tackle the three days of Session Three Personal Study.

3. Memorize this week's passage using the Beautiful Word Scripture memory coloring page. As a bonus, look up the Scripture memory passage in different translations and take note of the variations.

4. If you agreed to bring something for the next session's Opening Group Activity, get it ready.

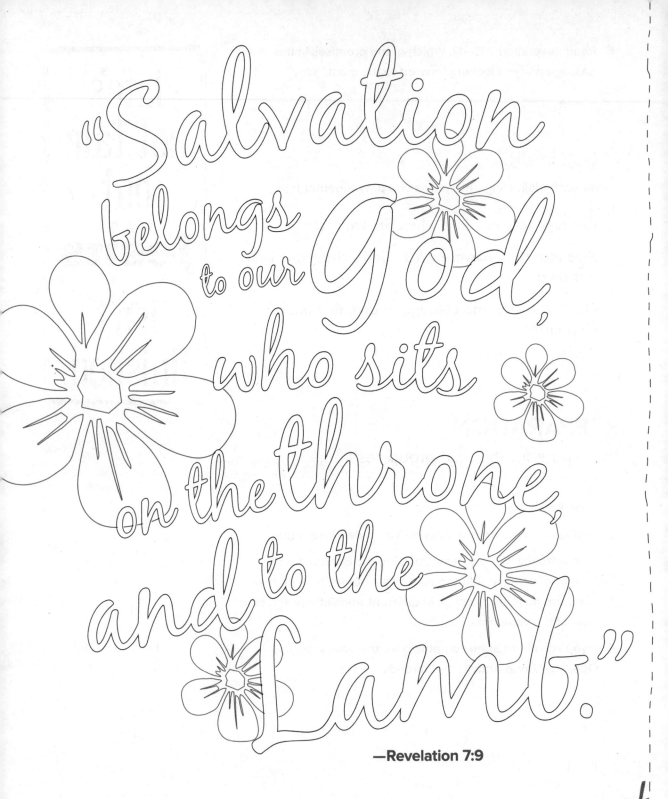

"Salvation belongs to our God, who sits on the throne, and to the Lamb."

—Revelation 7:9

PERSONAL
STUDY TIME

DIGGING INTO THE

Beautiful
WORD™
BIBLE STUDIES

REVELATION

WHEN LIFE'S NOT FAIR

DAY 1
REVELATION 7

After the six seals are opened, John presses pause as the winds calm, to reorient us to the goodness and faithfulness of God. This chapter reveals that if you have come into relationship with Jesus Christ and his work of salvation, you can rest assured you are marked by God for eternity, your sacrifices will be rewarded, you will participate in the greatest worship experience of all time.

1. Read Revelation 7:1–3. What do 2 Corinthians 1:22 and Ephesians 1:13 reveal about how you've been sealed by God? How have you experienced the Holy Spirit at work in your life this week?

In John's list of the tribes of Israel, one of the original tribes, Dan, is missing. This tribe was guilty of idolatry, and reminds us that we also must root out all forms of idolatry in our own lives.

2. Read Revelation 7:4–8. Take a moment to ask God to reveal any idols—those things you tend to overemphasize, put your trust in, or get fuel for your life from other than Christ. Circle all that apply. Ask God to liberate you from them.

Politicians	Employers	Celebrities
Savings Accounts	Overeating	Working Hard
Job Title	Accomplishments	Friendships
Spouse/Children	Being in Shape	Approval of Others
Busyness	Perfection	Sports
	Alcohol/Medication	

> In antiquity, a **signet ring** was pressed into **wax** or **clay** to create •••• a **seal**. Just as the **scrolls** were sealed, •••• now **God's people** are sealed to show their **ownership**, **protection**, and **authentication** by **God**.

The scene suddenly shifts as John looks at the breadth and depth of those standing before the throne in white clothes, which symbolize their purification and cleansing by the blood of Christ.

3. Read Revelation 7:9–10 and Matthew 21:7–9. What parallels do you see between these passages?

The mighty angels respond to the overwhelming praises of the multitudes by falling on their faces before the throne, much like John did in Revelation 1:17.

4. Read the words of worship these prostrate angels proclaim in Revelation 7:11–12. What seven attributes are ascribed to God's worthiness? How does this list compare to the one in Revelation 5:12? How can you make this your go-to heart cry to God?

#1

#2

#3

#4

#5

#6

#7

John says 144,000 (12 x 12,000) are sealed from the tribes of Israel (v. 4), suggesting they are **Jewish Christians.** The numbers 12, 12,000, and multiples of them are used frequently throughout Revelation to represent completeness and wholeness—whether it's the city that's 12,000 stadia in length (21:16) or the tree of life bearing 12 crops of fruit (22:2).

Next John is asked a question which he cannot answer, but which the asker already knows the answer to.

5. Read Revelation 7:13–14. Who are those who are dressed in white?

In fact, the law requires that nearly everything be cleansed with blood, and without the shedding of blood there is no forgiveness.

Hebrews 9:22

One of the most hotly debated issues regarding Revelation is whether believers will be removed before, during, or after the tribulation. This removal is often called the rapture. The actual word *rapture* doesn't appear in the Bible. First Thessalonians 4:17 describes Christians being "caught up," based on the Latin word *rapere*. Many ask when this will happen, and extensive Scripture-based arguments are made to support all perspectives.

Those who hold a pre-tribulation perspective believe all Christians will be removed before the great suffering. The mid-tribulation perspective is that believers will be removed half-way through, before the most intense judgments fall on humanity. The post-tribulation perspective holds that believers will go through the tribulation, with many dying for their faith. No matter what your perspective, the Christian life has always included tribulations in every age.

6. Look up the following passages. What does each one reveal about trials and suffering we will face?

 John 16:33:

 Acts 14:22:

 Colossians 1:24

 1 Peter 4:12:

Though you may not be going through the suffering described in Revelation, sometimes it can feel like it—as if everything's going wrong, everything is falling apart. John's words strengthen weary hearts by encouraging us to never give up hope on the one who rises with victory.

7. Read Revelation 7:15–17. Which of God's responses toward faithful believers in this passage are most meaningful to you now? Why?

8. Read Psalm 90:12. How does Revelation challenge you to number your days in such a way that you can gain a heart of wisdom?

> Wormwood (v. 11) is a bitter herb found in the Middle East and mentioned in other passages, including Jeremiah 9:15 (NASB) and Amos 5:7 (NASB).

...............

...............

...............

...............

...............

...............

...............

...............

DAY 2
REVELATION 8-9

After the interlude of chapter seven, we return to the final, seventh seal. All worship and singing quiets as we glimpse God's concern for the persecuted saints. During morning and evening sacrifices in the temple, a golden censor or pan was used to carry coals to the altar of incense in order to ignite the fragrance.

1. Read Revelation 8:1–5. The scene describes the prayers of the saints as a sweet fragrance. On the continuum below, mark how attentive you feel God is to your prayers. Explain.

◀||▶

God doesn't seem
to respond to my
prayers.

God seems to
be very responsive
to my prayers.

SCRIPTURE	TRUMPET NUMBER	RESULT OF TRUMPET	
Revelation 8:7			
Revelation 8:8–9			
Revelation 8:10–11			
Revelation 8:12			

Once the seventh seal is opened, angels blow seven trumpets and judgment is unleashed. Shofar trumpets were made of ram's horns. They were used for many reasons, including the marking of the beginning of the Sabbath and the death of someone of status.

2. In each of the following passages, how are the shofar trumpets used? How do these passages relate to the seven trumpets?

 Isaiah 27:13

 Zephaniah 1:15–16

 Matthew 24:31

Darkness was often used as a symbol of God's judgment. It accompanied Christ's death (Matthew 27:45) and was included in prophecies about Babylon (Isaiah 13:10) and Jesus' prophesies about the last days (Matthew 24:29).

3. Read Revelation 8:6–13 and the passages in Exodus, and then fill in the chart below.

	SCRIPTURE OF PLAGUE	RESULT OF PLAGUE	PARALLELS YOU SEE BETWEEN EXODUS AND REVELATION
	Exodus 9:23–26		
	Exodus 7:19–21		
	Exodus 10:21–23		

MENTIONS OF **the abyss** ALSO APPEAR IN 11:7 AND 17:8 AND REFER TO THE PLACE WHERE THE BEAST COMES FROM. WHEN OPENED, IT RELEASES **smoke, strange locus-like creatures,** AND **darkness.**

4. Through the trumpet blasts, God is undoing some of creation before creating heaven and earth anew. Look up the following passages. Which of the trumpet judgments undo what happened during creation?

Genesis 1:9–10

Genesis 1:11–12

Genesis 1:14–19

5. John gives twice as much attention to the fifth and sixth trumpet as he does to the first four combined, as the disasters continue to intensify. Read Revelation 9:1–21 and fill in the chart below.

SCRIPTURE	TRUMPET NUMBER	RESULT OF TRUMPET
Revelation **9:1–12**		
Revelation **9:13–21**		

The unleashing of these brutal plagues is for one purpose only: to bring humanity to repentance. God's desire is that every person would avoid the suffering that comes with judgment, and that everyone would repent and turn to him.

The book of Joel (1:6; 2:4-10) also describes armies of locusts or something similar attacking Israel as a judgment from God. As John struggles to describe the locust-like creatures escaping from the smoke in Revelation 9, he uses the word *like* nine times. These odd creatures are probably not insects but represent dark forces the children of God are protected from. Their leader, *Abaddon* in Hebrew or *Apollyon* in Greek, means "destroyer."

Clouds ARE ASSOCIATED WITH **GOD'S PRESENCE**, LIKE WHEN MOSES ASCENDED MOUNT SINAI (EXODUS 19:9–11).

Rainbows ARE ASSOCIATED WITH GOD'S **PROMISES**, LIKE WHEN GOD SENT A RAINBOW WITH A PROMISE TO NOAH AFTER THE FLOOD (GENESIS 9:11–16).

6. Read 2 Peter 3:9. How does this passage reflect God's desire for redemption of all of humanity—including you?

7. Read 1 Timothy 2:4. What does this passage reveal about God's desire for humanity?

8. Read Romans 2:4. How have you experienced the kindness of God in your life? How does this draw you closer to him?

DAY 3
REVELATION 10–11

Before the seventh trumpet, there's another interlude, much like that found in Revelation 7. This holy pause is a gift for us and for John, who was discouraged and heartbroken over the six trumpet judgments. With great compassion, God reorients John once again to his power, sovereignty, and promised victory.

1. Read Revelation 10:1–7. The attributes and kindness of God are seen throughout this passage. When you find yourself discouraged, which of the following are the most important for you to remember? Place check marks by all that apply.

........ God's goodness God's mystery

........ God's faithfulness God's promises for the future

........ God's acts in the past God's power over all things

........ God's provision God's presence

........ God's eternal nature God's promises are true

PLACING ONE'S FEET ATOP SOMETHING IS A SYMBOL OF

OWNERSHIP
(10:2).

THE ANGEL PLACES HIS RIGHT FOOT ON THE SEA AND HIS LEFT ON THE LAND, SYMBOLIZING THAT DESPITE ALL THAT'S BEING ALLOWED TO HAPPEN, ALL OF CREATION STILL BELONGS TO THE LORD.

God often instructed prophets like Daniel to seal up what they'd seen (Daniel 8:26). In Revelation 10, the seven thunders are sealed up and remind us that God is a mystery. He places boundaries between what we can know and what's off-limits. That means there are events in the closing age that we simply know nothing about. Revelation isn't written to satisfy our curiosities; it's written to reveal Christ.

Taking and eating a scroll describes consuming God's Word into the deepest part of our life, where the message transforms who we are. Through this ingested Word, we taste the sweetness of God's presence and promised victory, even when it's alongside the bitterness of judgment on those who refuse to trust him.

2. Read Revelation 10:9–11; Jeremiah 15:16; and Ezekiel 3:1–15. Who else ate the words of God? What was the result? How is studying Revelation both sweet and bitter to you? What does it look like for you to truly consume and be nourished by Scripture?

3. After John consumes God's word, he's called and commissioned to deliver God's message as a great privilege and responsibility. How does consuming God's Word bring clarity to your calling and commissioning? How are you stepping out in obedience and faith in response to God's Word right now?

The interlude continues in Revelation 11, as John receives another assignment after eating the scroll. He's instructed to take a reed, a lightweight type of hollow cane, and use it to determine the size of the temple and altar. This is important because measuring is a sign of ownership.

The outer court, where Gentiles and unbelievers gathered, represents those who are impure or unfaithful. By excluding this area, we are reminded that those in relationship with Christ receive blessing and spiritual security.

"I WILL MAKE JUSTICE THE **MEASURING LINE** AND **RIGHTEOUSNESS** THE **PLUMB LINE.**"

Isaiah 28:17

In the Old Testament, two witnesses were required in order to provide credible testimony (Deuteronomy 19:15). Now we're introduced to two prophets who deliver the news of God's judgment alongside the good news of Jesus for all who will believe in him. Some scholars believe the two witnesses are in the spirit of Moses and Elijah, who were present at the transfiguration (Mark 9:2–8). This is in part because they have the power to turn water into blood, like Moses, who appeared at the transfiguration (Exodus 7:17), and to close the heavens to stop rain like Elijah, who also appeared at the transfiguration (1 Kings 17:1). Other scholars believe the two witnesses represent two principles: the law and the prophets. Still others believe they reflect Peter and Paul or Jewish and Gentile believers.

The first mention of the beast in Revelation appears in 11:7. Both here and in 17:8, the beast emerges from the abyss, revealing its evil origin.

4. Read Revelation 11:1–14. Consider the following statements, based on the text. How do these supernaturally given powers reveal God's love and protective nature?

The two witnesses receive power to preach for 1,260 days.	
The two witnesses are protected from all who try to harm them.	
They have power to stop the rain and to turn water into blood.	
They will die but will be brought back to life.	

5. What is the result of the earthquake in verse 13? Do you believe God is active right now, saving those who repent? Explain.

6. In light of this passage, do you still believe there's no possible way this person will ever become one who gives glory to God? Is there anyone you've given up on spiritually, who you need to reconsider?

Just as this chapter opens with a scene of God's temple on earth, the chapter now closes with a scene of God's temple in heaven. While earth explodes with loss and pain, heaven explodes with wondrous worship.

7. Read Revelation 11:15–19. What stands out to you about the song of worship those in heaven sing? How does refocusing your life on God's presence change your perspective on the difficulties you face?

8. What does it mean to you to have a healthy fear of the Lord? Where do you struggle to revere, honor, and respond to God as holy?

Handel's "Hallelujah" Chorus draws on Revelation 11:15: "The **kingdom** of the **world** has become the kingdom of our **Lord** and of his **Messiah,** and he will reign **for ever** and ever."

As you reflect on your personal study of Revelation 7–11, what are the beautiful words that the **Holy Spirit** has been highlighting to you through this time? Write or draw them in the space below.

HOW
TO OVERCOME THE
ENEMY

REVELATION

OPENING GROUP ACTIVITY [10-15 MINUTES]

What you'll need:

▶ Sheet of blank paper for each person

▶ Pens, markers, and/or watercolors

1. Each participant is invited to use the paper and drawing/writing tools to create either a picture of what's described in Revelation 12:1–5 or a list (words or images) of symbols included in the description.

2. Discuss the following questions:

 ● Which elements of the imagery are most intimidating to you? Why?

 ● Which element of the imagery is the most hopeful for you? Why?

 ● What element of your drawing or list stood out to you the most? Why?

SESSION FOUR VIDEO [22 MINUTES]

NOTES: *As you watch, take notes on anything that stands out to you.*

▶ Revelation 12 provides a backdrop for what we've read in the first half of Revelation and lays the foundation for what we'll read in the second half.

▶ Evil always desires to destroy the promises and purposes of God.

▶ Revelation 12:5 is the gospel in a single verse—a powerful compression of the life, death, resurrection, and victory of Jesus Christ.

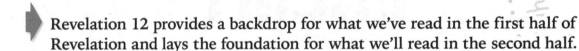

What caught your attention?

What made you reflect?

What surprised you?

▶ The Creator uses his own Creation, the earth, to drink up the enemy's spew. Once again, God wins! Once again, the dragon doesn't give up so easily.

▶ When you know your enemy, you can overcome your enemy.

▶ The last thing the enemy wants you to do is take your place, your position, as a faithful saint, an overcomer, a Victorious One. He spends most of his time trying to convince us that we're on the losing team.

▶ Let hell hear your holy battle cry.

▶ Unleash the power of oneness.

▶ March forward where you most want to shrink back.

REVELATION 12

GROUP DISCUSSION QUESTIONS [30-45 MINUTES]

1. C.S. Lewis warned, "There are two equal and opposite errors into which our race can fall about the devils. One is to disbelieve in their existence. The other is to believe, and to feel an excessive and unhealthy interest in them."[1] Which end of the spectrum do you tend to lean toward? Why?

2. In what area of your life do you most need to declare, "Satan is not strong enough and he has no place in my life"? (See Revelation 12:8.)

3. Margaret teaches,

 "Through Christ, God has been planning our victory over the enemy since the beginning of time. This is not a battle where you're on the sidelines watching. This is the battle we're in!"

 What verses in Revelation 12 support this? Describe a time when you've felt like you've faced a spiritual battle? What was the outcome?

4. What does it look like for "Hell to hear your battle cry" this week? What wedges has the enemy placed in your life and your relationships that are tearing apart Oneness? Who do you need to forgive, extend the benefit of the doubt to, or show compassion to?

[1] C. S. Lewis, *The Screwtape Letters* (HarperSan Francisco, © 1942; Harper edition, 2001), p. ix. 3.

5. Share a one-minute testimony of the work of Christ in your life. How can we become more intentional about overcoming through the word of our testimonies in everyday conversation?

6. Where are you most tempted to shrink back from God right now? What has the Holy Spirit placed on your heart that you've been resisting, dismissing, or coming up with really good excuses not to obey?

CLOSE IN PRAYER

Consider the following prompts as you pray together for:

▶ The ability to take a strong stand and let hell hear your battle cry

▶ Opportunities to share our testimonies and stories of Jesus

▶ Courage to march forward in the area in which we most want to shrink back

"THEY TRIUMPHED OVER HIM BY THE blood of the Lamb AND BY THE word of their testimony; THEY DID NOT LOVE THEIR LIVES SO MUCH AS TO SHRINK FROM DEATH."
Revelation 12:11

PREPARATION
To prepare for the next group session:

1. Read Revelation 12–18.

2. Tackle the three days of Session Four Personal Study.

3. Memorize this week's passage using the Beautiful Word Scripture memory coloring page. As a bonus, look up the Scripture memory passage in different translations and take note of the variations.

4. If you've agreed to bring something for the next session's Opening Group Activity, get it ready.

But he was not strong enough, and they lost their place in heaven.

—Revelation 12:8

SESSION
4

PERSONAL
STUDY TIME

DIGGING INTO THE

Beautiful WORD™

BIBLE STUDIES

REVELATION

HOW TO OVERCOME THE ENEMY

The fiery **dragon** symbolizes **Satan,** the enemy of God. **Red** represents blood and **loss** of life. The creature's seven **heads,** ten **horns,** and seven **diadems** reveal past and future worldly **kingdoms.** The dragon's desire to devour the child is reminiscent of Satan's attempt to destroy Jesus through the massacre of children under Herod's rule. Jesus' **rod** of iron symbolizes his **coronation** as King of All, and Jesus is snatched or lifted up to the right hand of the Father (v. 5).

DAY 1
REVELATION 12-13

In chapter 10, John was called to prophesy, and his insights continue in chapter 11. These are revealed in the format of seven signs, three of which are in heaven and four on earth; only one sign is good. The other six reveal God's judgment as well as the presence of evil in our world.

In Revelation 12, see the brutal persecution of the saints in the past, present, and future. This chapter can be divided into three sections: the birth of the child, the removal of the dragon, and the attack against the woman and her children.

1. Read Revelation 12:1–5. How does your sketch, painting, or list from the Opening Group Activity reveal the triumph of good over evil, of God over the adversary?

2. Read Revelation 12:6–10 and Ephesians 6:10–12. The events of the tribulation on earth are wedded to the spiritual battle taking place in the heavens. In what area of your life have you been waging war in your flesh, when the battle that's taking place is actually spiritual? What do you need to do to put on the full armor of God (see Ephesians 6:13–18)?

3. What are the names given to the adversary in each passage below? What do these names reveal about the character of Satan?

 Matthew 4:3:

 Matthew 6:13:

 Matthew 9:34:

 John 8:44:

 Ephesians 2:2:

 1 Peter 5:8:

4. How are the characteristics listed above the opposite of God?

5. Read Revelation 12:11. What elements are true of overcomers? Which of these come naturally to you? Which of these do you struggle with?

God controls all things, including the amount of time Satan is allowed to instigate mayhem. The woman is given two eagle's wings, representing God's protection. She is taken to the wilderness where she is sustained for another three and a half years. A great army opposes the woman, and they are swallowed up. The persevering, faithful saints frustrate Satan (the dragon). This causes the dragon to double-down in rage. He's again described with heads, horns, and crowns (12:3).

6. Read Revelation 12:12–13:1. On the continuum below, mark how much you recognize that you're part of a great spiritual battle.

| I never think I'm in a spiritual battle between good and evil. | I'm always aware I'm in a spiritual battle between good and evil. |

On the continuum below, mark how much you recognize that your faithfulness, righteousness, and holiness frustrate and anger the adversary.

| I don't think my faithfulness or faithlessness has much affect. | I'm highly aware my faithfulness pleases God and frustrates the enemy. |

How does this passage and your response to it challenge you to walk in greater faithfulness, holiness, righteousness, service, and prayer?

Revelation 13 contains many layers of meaning and symbols, and often the result is a wide range of speculation. However you interpret this mysterious chapter, remember this: Satan's plans come to a crashing end!

7. Read Revelation 13:2–18. Among the layers of symbolism, metaphor, and meaning, why do you think so many people become laser-focused on details like 666 or the mark on the right hand or forehead? If these details are overemphasized, how can they become distractions to reading Revelation as a great unveiling of Jesus Christ?

8. Read Daniel 7:1–28. How does this passage help you understand the mysteries of Revelation 12–13? How do the promises of victory in these passages encourage and empower you?

Some believe the leopard represents the

Greek Empire,

the bear represents the

Medo-Persian Empire,

and the lion represents the

Babylonian Empire.

The deadly wound may refer to a kingdom that was crushed and then revived or the description of the

Antichrist

coming back to life (17:8). Soon another beast (verse 11) emerges on the scene, known as

the final false prophet,

who heralds the Antichrist and his power and convinces the world to worship him as God. Though the Antichrist is primarily a **military** and **political** leader, many believe the false prophet will be a **religious** leader.

DAY 2
REVELATION 14–16

In Revelation 14, John reveals the victory of the 144,000 faithful followers. We also see the crashing of Babylon (which is representative of the Adversary's systems and rule), as well as the battle of Armageddon. The scenes of Revelation 13 and 14 contrast sharply.

1. Read Revelation 14:1. How does the appearance of the dragon in Revelation 13:1 contrast with the appearance of the Lamb in Revelation 14:1? How does the mark given by the beast in Revelation 13:16–17 contrast with the mark given by God in Revelation 14:1? What do these stark differences reveal about God?

2. Read Revelation 14:2–5. What are some of the spiritual signs in your life that indicate you've been marked by God? How are earthly victory and heavenly worship connected in this passage?

The Greek word *eschatos* can be translated "last," and that's where scholars derive the word *eschatology*, the study of the last things, end times, or God's plans for the future.

After highlighting the triumph of the saints, a series of angels appear on the scene.

3. Read Revelation 14:7–20. How do you hold the grimness of judgment alongside the invitation to know and obey God in your heart?

We've now arrived at the shortest chapter in the book of Revelation. Chapter 15 opens with a promise that the seven angels will pour out the *last* seven plagues, because through this God's response to evil is complete.

4. Read Revelation 15:1–8. What characteristics of God are mentioned in the victorious song (vv. 3–4)? Why do you think John continues to reorient us toward this heavenly perspective? How does this give you hope?

5. Notice that it's the overcomers who join in worship and watch this scene unfold (v. 2). Remember some of the suffering that you have gone through. What have those times of prolonged pain taught you about the power of worship?

When John describes "the **tabernacle** of the covenant law," he is referring to the **tent** constructed by **Moses** that served as a tabernacle for the Israelites in the **wilderness**. The inner room was known as the **Holy** of **Holies** or Most Holy Place. **Angels** emerge from this room in white, bright clothes, representing their **purity** and God's **glory**.

During the seal judgments (Revelation 6) and trumpet judgments (Revelation 8–9), a portion of the world is affected, but now the entirety suffers with each bowl. The intensity increases, too. In previous judgments, months often pass between judgments, but these occur bam, bam, bam, as we see God's response to evil unleashed. All of these judgments are reserved for those who reject God and his mercy and choose to worship the Antichrist or evil (v. 2).

Many parallels can be found between the seven trumpets and the seven bowls. Both are reminiscent of the plagues on Egypt preceding the exodus. Yet while the trumpets tend to focus on the effects of nature, the bowls zero in on the effects of humanity. As a result, some believe the two series are the same; others believe they are two different sets of events.

6. Read Revelation 16 and fill in the chart below.

SCRIPTURE	BOWL NUMBER	RESULT OF BOWL	INTERESTING NOTE
Revelation **16:2**			The sixth plague on the Egyptians was boils (Exodus 9:10–11). Job was afflicted by boils (Job 2:7) when he was allowed to be tested by the adversary. The beggar Lazarus was described by Jesus as being covered in boils (Luke 16:21).
Revelation **16:3**			This is a reversal of creation as found in Genesis 1:21. The first plague of Egypt included the death of sea life (Exodus 7:17–21). This is reminiscent of the second trumpet (Revelation 8:8–9).
Revelation **16:4**			Water is essential to human and animal life. Without water, open sores can't be cleansed, and humans cannot survive.

SCRIPTURE	BOWL NUMBER	RESULT OF BOWL	INTERESTING NOTE
Revelation **16:8–9**			The difficulty caused by lack of access to water is compounded by excessive heat.
Revelation **16:10–11**			Gnawing at one's tongue represents an unsuccessful attempt to relieve pain.
Revelation **16:12–14**			Frogs were considered unclean animals according to dietary laws (Leviticus 11:10–11). The imagery and description reveal these forces of darkness as vile, deceitful, and instigating conflict. They were unleashed during the second plague on the Egyptians (Exodus 8:2–6).
Revelation **16:17–21**			Jesus said, "It is finished," as he breathed his last on the cross (John 19:30). After Christ's death, a powerful earthquake took place (Matthew 27:51). Yet this earthquake is the most devastating in human history— one that's off the Richter scale. Every city is destroyed, except for Jerusalem, which is split in three, in preparation for the new Jerusalem that's coming (Revelation 21:10). Also, the seventh plague on Egypt was hail (Exodus 9:23–24).

ARMAGEDDON COMES FROM THE HEBREW WORD HAR, MEANING "HILL," AND MAGEDDON, OFTEN THOUGHT TO BE AN ANCIENT CITY KNOWN AS MEGIDDO AND LOCATED ABOUT 60 MILES NORTH OF JERUSALEM. SOME BELIEVE THE FINAL BATTLE BETWEEN GOD AND THE ADVERSARY WILL LITERALLY TAKE PLACE ON A NEARBY VALLEY. OTHERS TRANSLATE MAGED AS A "PLACE OF GATHERING TROOPS," ALLUDING TO A SPIRITUAL BATTLE WHERE GOD TRIUMPHS OVER THE FORCES OF DARKNESS ONCE AND FOR ALL.

In Revelation 16:5–7, we read of sinners drinking the blood of the saints and prophets, meaning they reveled in the death of these holy ones. They are made to drink the blood as their punishment.

7. Revelation 16:15 encourages us to stay spiritually awake. Read Mark 13:33–37. Why is it important to be loyal and alert to Christ at all times and not just in the end times? What can you do to become more spiritually alert and loyal to Jesus in your everyday life?

8. Second Peter 3:11 asks, "Since everything will be destroyed in this way, what kind of people ought you to be?" In light of what you've read so far in Revelation, how would you answer this question? Read 2 Peter 3:12. What does it look like to be "holy and godly" in your everyday life?

DAY 3
REVELATION 17–18

After the seven final bowl judgments are unleashed, John pauses to give us more of the backstory of several mysterious elements, including Babylon the great, the Antichrist's influence, and the beast. The scene opens with the great prostitute sitting by many waters, which represent humanity (v. 15). She rides on the scarlet beast, representing the fusion of religious and political influence. But the beast is covered in blasphemy, revealing its true nature (Revelation 13). As people drink the false teachings, they can no longer distinguish between truth and falsehood.

1. Read Revelation 17:1–6. What does this passage reveal about the true nature of the woman and her attitude toward God?

Now we turn to one of the most difficult passages to interpret. The scene describes seven kings who have fallen, a current one, and a final one to come. The number seven matches the seven hills on which the woman sits. This is followed by ten horns and ten kings. Some interpreters identify past emperors or kings who preceded John or ruled during his lifetime. Regardless of how you read this passage, the important thing to remember is that these kings' goal is to give their power to the religious and economic system of the beast, to oppress people, and to draw them away from God. We also see here, though, that no plan, no power, no purposes can thwart God's plan, power, and purposes for our lives and this world.

THE ORIGINAL BAB–EL, MEANING "GATE TO GOD," BECAME KNOWN AS BABEL, OR A PLACE OF CONFUSION DESCRIBED IN GENESIS 11. THIS IS THE PLACE THAT LATER BECAME KNOWN AS BABYLON. MENTIONS OF BABYLON IN MANY PARTS OF THE BIBLE REPRESENT THE ACTUAL CITY AND EMPIRE, BUT IN REVELATION AND OTHER PARTS OF THE BIBLE, IT MORE LIKELY REPRESENTS A RELIGIOUS AND ECONOMIC SYSTEM THAT'S UNDER THE ENEMY'S DOMINION, WHICH CREATES CONFUSION AND TURNS PEOPLE'S HEARTS FROM GOD.

2. Read Revelation 17:7–18. How does the enemy turn against the woman (vv. 15–16)? In your own life, how have you seen the enemy and sin make one promise but deliver something entirely different? How have you seen God use something that seemed truly terrible in order to reveal his goodness and glory?

3. Sometimes it can seem like evil is winning in our world. How does this passage ground you in the truth that God remains in control even when everything seems out of control?

Now we see the swift crashing of the mysterious Babylon, the empire of the Antichrist, once and for all. This takes place in "one hour" (18:19)—not a literal 60 minutes, but a quick period of time.

4. Read Revelation 18:1–3. What are the characteristics of Babylon described in this passage? Of these characteristics, which are most appalling to you? Are any tempting to you?

5. Read Revelation 18:4–8. What invitation is given to God's people in verse 4? In what ways is God asking you to disentangle yourself from the ways of the world? What is your response?

6. Read Revelation 18:9–20. Make a list of all the elements that reveal Babylon's wealth, arrogance, and self-indulgences in the space below. Which of them tempts you away from God's presence and purpose?

7. Read Revelation 18: 21–24. What does this passage reveal about God's attitude toward evil? What does this passage reveal to you about God's attitude toward the saints and those who are willing to give up everything to follow Jesus? How does this give you hope right now?

8. Remembering that this description of Babylon is likely intended to be symbolic, what is your own "Babylon," and how can you, in partnership with God, destroy its power over you?

"Babylon, the **jewel** of kingdoms, the **pride** and glory of the **Babylonians**, will be **over-thrown** by **God** like Sodom and Gomorrah. She will never be inhabited or lived in through all generations; there no nomads will pitch their tents, there no shepherds will rest their flocks."

Isaiah 13:19–20

As you reflect on your personal study
of Revelation 12–18, what are the beautiful words
that the Holy Spirit has been highlighting to you
through this time? Write or draw them
in the space below.

SESSION
5

WHEN
ALL HELL
BREAKS LOOSE

REVELATION

OPENING GROUP ACTIVITY (10-15 MINUTES)

What you'll need:

▶ A music player (such as a smart phone) with two selections pre-chosen and ready to play: soft instrumental music such as a piano hymn, and a recording of the hymn "Thou Art Worthy."

1. Invite one volunteer to read the chorus found in Revelation 19 while the instrumental music selection plays softly in the background. Here are the words:

> Hallelujah! Salvation and glory and power belong to our God, for true and just are his judgments. He has condemned the great prostitute who corrupted the earth by her adulteries. He has avenged on her the blood of his servants. Hallelujah! The smoke from her goes up for ever and ever. Amen, Hallelujah! Praise our God, all you his servants, you who fear him, both great and small! Hallelujah! For our Lord God Almighty reigns. Let us rejoice and be glad and give him glory! For the wedding of the Lamb has come, and his bride has made herself ready. Fine linen, bright and clean, was given her to wear.

2. Invite everyone in the group to listen or sing along with the recording of "Thou Art Worthy," a hymn based on Revelation 4:11 and the basic refrain of glorious praise we've encountered numerous other times as we've studied Revelation 1–19. Here are the words:

> Thou art worthy, thou art worthy, thou art worthy, O Lord, to receive glory, glory and honor, glory and honor and pow'r. For thou hast created, hast all things created, thou hast created all things. And for thy pleasure, they are created. Thou art worthy, O Lord.

3. Discuss the following questions:

- Reflecting on the words of worship from Revelation 19, which statements stand out to you the most? Why?

- Of the two choruses of praise (Revelation 19 and "Thou Art Worthy"), which is the easier for you to sing? Why?

- Why do you think the saints in Revelation 19 celebrate the fall of evil? Why is this an appropriate response for them—and for us?

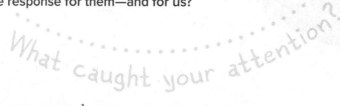

SESSION FIVE VIDEO (24 MINUTES)

NOTES: *As you watch, take notes on anything that stands out to you.*

▶ The saints roar, "Hallelujah!" in celebration of God, who has stopped the carnage of evil and oppression.

▶ This is the moment we've all been waiting for. Jesus returns as the Warrior and Judge—the one who comes in great power to conquer *all* enemies, *all* evil, *all* darkness.

▶ Even if hell is breaking loose in your life—through circumstances and situations you'd never choose—heaven is still crashing in.

▶ Revelation 20 is like watching a movie in which the good guys are taking care of the bad guys, and while they're distracted, the villain sneaks away.

▶ Neither speed and efficiency nor ease is God's highest value. Here we see that what's celebrated is holiness, righteousness, and faithfulness.

▶ Jesus doesn't always promise us *out*, but he always promises us *through*.

▶ You can either cling to the crisis, or you can cling to Christ. You do not have arms big enough for both.

▶ Even in the darkness, all heaven is crashing in. And Christ wants to crash in through you.

GROUP DISCUSSION QUESTIONS [30–45 MINUTES]

1. Margaret teaches,

 "When you find yourself beaten down by life, ready to give up and throw in the towel, when you feel like everything has fallen apart and there's no one to pick up the pieces, Revelation 19:11–16 is the image I want you to hand-paint in your mind."

 Reflecting on this passage, what one detail from this description of Jesus' return is most meaningful to you now? Why?

2. Describe a time when you've seen heaven crash into a difficult situation in your life. What did it reveal to you about God?

3. Where in your life is hell breaking loose now or perhaps already broke loose in the past? Which of the following fills you with more extravagant hope—God will get you *out* of this or God will get you *through* this? Which message does Revelation seem to echo to you? Why?

4. Read Psalm 23. In the situation you mentioned in question 3, or perhaps in a different one, have you been begging, "God, get me out of this!"? Maybe Jesus is answering, "I'm here to get you through this!" How does knowing that Jesus is with you empower you for the journey?

5. In what area of your life have you been clinging more to the crisis than to Christ? What does it look like to place a pin in God's hope and future for you right now (Jeremiah 29:11)?

6. Who is one person you can rally around right now to help them put a pin in the fact that God has a hope and future for them?

Even when all HELL breaks loose, HEAVEN is still CRASHING IN.

CLOSE IN PRAYER

Consider the following prompts as you pray together for:

▶ Strength to let go of the crisis and cling to Christ

▶ Eyes to see those who need help clinging to God's hope and future

▶ Opportunities to see how heaven is crashing in right now

PREPARATION
To prepare for the next group session:

1. Read Revelation 19–21:5.

2. Tackle the three days of Session Five Personal Study.

3. Memorize this week's passage using the Beautiful Word Scripture memory coloring page. As a bonus, look up the Scripture memory passage in different translations and take note of the variations.

4. If you've agreed to bring something for the next session's Opening Group Activity, get it ready.

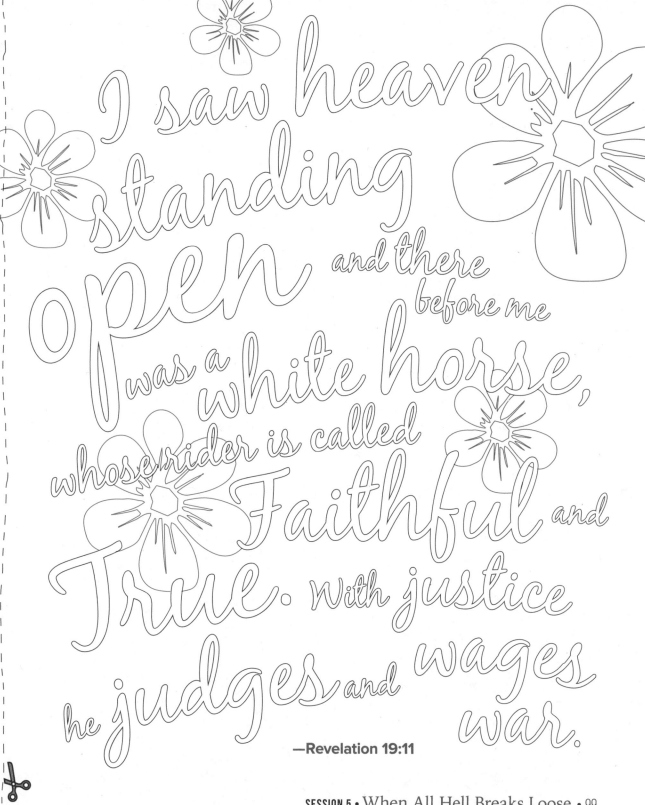

I saw heaven standing open and there before me was a white horse, whose rider is called Faithful and True. With justice he judges and wages war.

—Revelation 19:11

PERSONAL
STUDY TIME

DIGGING INTO THE

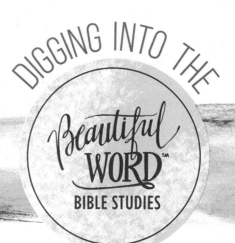

Beautiful
WORD™
BIBLE STUDIES

REVELATION
WHEN ALL HELL BREAKS LOOSE

DAY 1
REVELATION 19

1. Read Revelation 19:1–8. What word starts each of the four shouts of praise for the fall of Babylon? (Hint: vv. 1, 3, 4, 6) What is the focus of each of the four bursts of praises in this passage? Draw a line connecting each passage and the reason for praise.

Revelation 19:1–2	God's worthiness of praise and glory
Revelation 19:3	God's taking his rightful reign on the throne
Revelation 19:4	God's justice and rescue
Revelation 19:6–7a	God's crushing of rebellion

2. Read Psalm 113:1. How have you found the Psalms helpful in your own times of worship and prayer?

In the Old Testament, Israel was often referred to as God's bride (Ezekiel 16:8). In the New Testament, the church is referred to as Christ's bride (Ephesians 5:23–32). Jesus frequently used wedding and banquet imagery in the parables of God's kingdom (Matthew 22:2–14; 25:1–13; Luke 14:16–24).

Hebrew weddings were giant celebrations that took place in several phases—first, the betrothal, when the couple formally committed to be married; then, the couple's presentation, which included festivities for several days; next, the exchanging of vows in a ceremony and subsequent huge celebration on the eve of the wedding day; followed, finally, by the wedding ceremony itself, whose festivities lasted for many days. People traveled far and wide for the celebration.

3. Read Revelation 19:7–9. How does the description of the bride contrast with the description of the prostitute of Babylon in Revelation 17:3–6? How does this sharp contrast give clarity to who you're called to be as a follower of Christ?

When John writes, "For it is the Spirit of prophecy who bears testimony to Jesus" (v. 10), we are again reminded that this book is a revelation or unveiling of Jesus.

4. Read Revelation 19:10. After receiving multiple warnings against idolatry, John still falls prey to worshiping something other than God. Why do you think John included this confession?

"I say to you that many will come from THE EAST AND THE WEST, and will take their places at the feast with Abraham, Isaac and Jacob in the kingdom of heaven."

MATTHEW 8:11

As Revelation progresses, so does John's ability to witness the unfolding of events. In Revelation 4:1, John saw a *door* standing open in heaven. In Revelation 11:19, he glimpsed *the temple in heaven* standing open, and now in Revelation 9:11, *all of heaven* stands open.

5. Read Revelation 19:11–16. In the box below, draw a sketch or make a list of what's described. What parallels can you find with the first vision in Revelation 1:12–20? What aspects of your drawing or list give you the most hope?

6. Read Revelation 19:17–18 and Ezekiel 39:17–20. Why do you think such violent and grotesque imagery is used to describe the victory?

7. Read Revelation 19:19–21. One of the most fascinating details about this passage is that there's no actual battle fought in this passage, perhaps because this is a battle in heaven. Where in your life do you most need to lay hold of the truth that the battle has already been fought and God wins?

8. How does this chapter demonstrate the power and freedom that come when heaven crashes in?

DAY 2
REVELATION 20

After the glorious sounds of rejoicing and the toppling of Babylon and the beast, Satan is bound for the thousand-year reign of Christ. Some interpret the thousand years as literal, while others see it as a nonspecific long time.

Much like the controversy over the pre-, mid-, or post-tribulation rescue of the saints, passionate Jesus-loving believers hold a variety of views regarding what's called the millennium. Pre-millennialists believe Jesus returns to earth before the thousand-year reign. Post-millennialists believe Jesus returns after the thousand-year reign. Amillennialists believe this symbolic period of time is occurring now, is not of any precise length, and began with Christ's resurrection.

1. Read Revelation 20:1–6. In the chart below, fill in the primary characteristics of the millennium. Note which of these have already been fulfilled and which are yet to be fulfilled.

SCRIPTURE	CHARACTERISTIC OF THE 1000 YEARS	HAS BEEN FULFILLED THROUGH CHRIST	YET TO BE FULFILLED
Revelation **20:1**			
Revelation **20:2**			
Revelation **20:3**			
Revelation **20:5**			

Some believe that some of the battle scenes described in Revelation are the same, just told from different perspectives. Some view Revelation 20:7–10 as the same battle as the one described in 19:17–21.

2. Read Revelation 20:7–10 and Revelation 19:17–21. What consistencies do you see between these battles? What differences do you see between them? What's the main takeaway from both of these battle scenes? How does this fill you with hope?

3. Read Revelation 20:11–13. According to this passage, who are these people? How are they described? What are they judged by?

Ezekiel 38 describes Gog (a leader) and Magog (his people) attacking Israel. As a result, God sends rain, hail, fire, and an earthquake to destroy them.

4. Read Romans 2:6–8 and 2 Corinthians 5:10. How do you tend to respond to the idea of God bringing justice through judgment? Mark on the continuum below. What part of your response is healthy? Are there any parts of your response that are unhealthy? Explain.

I think God will judge me through the lens of Christ and his love.

I'm scared of God's judgment and facing everything I've done wrong.

The book of life is mentioned in Revelation 3:5 and contains the names of the redeemed.

5. Read Romans 8:1. How do judgment and condemnation differ? How does this passage give you confidence and assurance in Christ?

6. The judgment is not a spreadsheet trying to balance good works versus bad; rather, it demonstrates the balance between grace and obedience. How do you see grace and obedience working in your life?

7. Read Revelation 20:14–15. Death and Hades are personified in this verse. How does this fulfill 1 Corinthians 15:26? What joy do you find in the promise of Revelation 21:4?

8. What does this chapter reveal about what happens when heaven crashes in?

DAY 3
REVELATION 21:1-5

God delivers an incredible gift: a new heaven and earth. In the process, he reverses the evil consequences of sin and suffering. This Holy City, dressed as a bride, speaks to our life with God and his personal relationship with us.

1. Read Revelation 21:1–5. The tears wiped away represent the stunning fact that there will be nothing disappointing, sad, or deficient. In what areas of your life are you struggling with these current realities? In what ways has Jesus been wiping away your tears even now?

 Disappointments:

 Sadness:

 Deficiencies:

2. How do the new heaven and earth fulfill the promise of Leviticus 26:11–13?

3. What do you most long for God to make new in your life?

> It's worth noting that the sea, which is the **SOURCE** of the beast (13:1) and **PLACE** of the **DEAD** (20:13), is eliminated.
>
> ───
>
> While some interpret this as a literal sea, others recognize it as a **MORAL** and **SYMBOLIC CLIMATE** in which there is **NO EVIL**. The landscape of God is shaped wholly by his **GOODNESS**.

4. What does 1 John 5:4–5 reveal about those who overcome?

5. How is Isaiah 65:17–19 fulfilled in this passage? What promises of God do you most long to have fulfilled?

6. What hope do you find in this promise that the former things will not be remembered?

7. Read Hebrews 10:11 and Hebrews 13:14. How does looking forward to this new city affect how you face today?

8. What promises given to the churches in the opening of Revelation are fulfilled now during the end?

Revelation 2:26:

Revelation 3:12:

As you reflect on your personal study of Revelation 19–21:5, what are the **beautiful words** that the **Holy Spirit** has been highlighting to you through this time? Write or draw them in the space below.

THE PROMISES
OF
HEAVEN

REVELATION

OPENING GROUP ACTIVITY (10–15 MINUTES)

What you'll need:

▶ Each person to bring food to share

▶ Party balloons or fun decorations

▶ Digital camera or cell phone with camera

1. Decorate the room with balloons, streamers, wildflowers, and anything you can find to create a festive atmosphere.

2. Enjoy laughing, talking, sharing, and catching up as you eat together.

3. Invite participants to share what they've been learning about Jesus through Revelation.

4. Take a photo of your group and send to hello@margaretfeinberg.com. She wants to see your smiling faces!

5. Ask participants to read Revelation 21, taking turns reading aloud.

6. Discuss the following:

 ● What are you most looking forward to in the new heaven and earth?

 ● What do the detailed descriptions of this passage reveal about Jesus?

SESSION SIX VIDEO (21 MINUTES)

NOTES: *As you watch, take notes on anything that stands out to you.*

 Maranatha, found in 1 Corinthians 16:22, can be translated "the Lord has come," or "Come, O Lord."

 Sometimes people portray heaven as a place of perfection and earth as a second-rate, shabby home where we have to do our time. Here we see God is making both heaven and earth new.

➤ Throughout the Old Testament the sea often symbolizes chaos and evil. When God makes all things new, there's no place, no space for chaos or evil.

➤ God comes to us, looks us in the eye, face to face, sees the depth of our pain, and wipes it away.

➤ No more duct-tape repairs or trying to piece things together or scraping to get by or make do.

➤ The promise of all things new comes from the one whose name is Faithful and True.

To the thirsty, hungry, hurting, and heartbroken, Jesus says, "Come!"
To the distressed, depressed, and down in the dumps, Jesus says, "Come!"
To the anxious, afraid, and uneasy, Jesus says, "Come!"
To the joyful, grateful, and celebratory, Jesus says, "Come!"

➤ Do you believe this infant, Jesus, grew up and delivered the kind of teachings that set people's hearts on fire for heaven and quenched the flames of hell? That through him, evil has been overcome and will be overcome? That he wants to use you to take evil out of circulation?

REVELATION 21:5—22:21

GROUP DISCUSSION QUESTIONS (30-45 MINUTES)

1. Describe a time when you were amazed by the good things God had up his sleeve for you. In what area of life do you most struggle to believe God has good things up his sleeve for you? What promises from Revelation assure you that God's intentions toward you are good and joyous?

2. Describe a time when you experienced Maranatha—"The Lord has come." In what area of your life are you praying, "Maranatha—Come, O Lord" now?

3. Read Revelation 21:4. Of all the promises tucked into this verse, which stands out as the most meaningful to you right now? Why?

4. Margaret says,

"Revelation confronts us all with a decision. Do you believe this book enough to stake your life on it? Do you believe evil and good exist? Do you believe God loved this world so much that he sent his only Son, Jesus, and through him evil has been overcome and will be overcome?"

Which of these are the easiest to believe? Which of these are the hardest to believe? Why?

5. Reflecting on the discussion and notes from the previous sessions, how has your understanding of Jesus grown or changed through his great unveiling in the pages of Revelation? What are you most excited to share about Jesus with others as a result of this study? What does it look like for you to live out the extravagant hope found in Christ in everyday life?

6. How would you sum up the book of Revelation in a few words? What's the most beautiful aspect of Revelation to you? What's your biggest takeaway from this Beautiful Word study? How will you live your life differently because of this discovery?

GOD has GOOD THINGS up HIS sleeve for you.

CLOSE IN PRAYER

Consider the following prompts as you pray together for:

▶ The comfort of Christ's presence in all things

▶ Faith to believe God has good things up his sleeve for us

▶ Renewed hope in the glorious promises of heaven

PREPARATION
To conclude this study:

1. Read Revelation 21:5–22:21.

2. Tackle the three days of Session Six Personal Study Time.

3. Memorize this week's passage using the Beautiful Word Scripture memory coloring page. As a bonus, look up the Scripture memory passage in different translations and take note of the variations.

He will wipe every tear from their eyes. There will be no more death or mourning or crying or pain, for the old order of things has passed away.

—Revelation 21:4

PERSONAL STUDY TIME

DIGGING INTO THE

Beautiful WORD™

BIBLE STUDIES

REVELATION

THE PROMISES OF HEAVEN

DAY 1
REVELATION 21:6-21

Just as we discovered the names of God in the opening chapter of Revelation, now we see an abundance of names and titles again.

1. Read Revelation 21:6–8. How does the Lord's response to those who are thirsty contrast with those who are unbelieving? What does this passage reveal about God's heart toward all who seek him?

2. Read Revelation 21:9–14 and Genesis 2:8–20. What similarities are there between the new garden city of God and the Garden of Eden? How does this encourage you today?

3. How does God reverse the effects of the fall in Genesis 3:1–24 through the new heaven and earth?

4. Read Revelation 21:15–21. Using the approximate color code for the precious stones mentioned, sketch a picture of what's described in the text.

PRECIOUS STONE	COLOR	SKETCH
Jasper	White / translucent	
Gold	Gold	
Agate / Chalcedony	Sky blue	
Sardius	Orange to brownish red	

PRECIOUS STONE	COLOR	SKETCH
Chrysolite	Goldish yellow	
Beryl / Aquamarine	Blue / blue-green	
Topaz	Yellowish	
Chrysoprase	Apple green	

PRECIOUS STONE	COLOR	SKETCH
Jacinth	Red/ reddish brown	
Amethyst	Purple	
Pearl	Pearl	

5. What details of the new garden city are most surprising to you? Which element do you most want to experience? Why?

THE **tree of life** SYMBOLIZES **continual blessing** AND **eternal life.**

IT BEARS TWELVE FRUITS, ONE EACH MONTH.

THE GREEK WORD TRANSLATED *HEALING* MEANS "THERAPEUTIC," SO THE LEAVES WILL ENRICH OUR LIFE IN HEAVEN.

6. Read Revelation 21:22–27. What stands out to you most in this passage?

7. Why do you think the gates of heaven don't need to be shut (vv. 25–27)? What does this reveal to you about the character of God?

8. What parts of heaven are you most excited about?

DAY 2
REVELATION 22

1. Read Revelation 22:1–5. Sketch a picture of the scene in the box on the next page. What surprises you most about this scene? What details fill you with the most hope about heaven?

...
...
...
...
...

2. Read Genesis 3:14–24. How are the consequences of what happened in the garden reversed in the new heaven and earth? What consequences of sin do you most long to have reversed in your life?

In antiquity, criminals were often prohibited from seeing the king's face. Thus, seeing the face of God is one of the great Old Testament promises. While Moses was not able to see it (Exodus 33:20–23), Jesus promises those with a pure heart will see God's face (Matthew 5:8).

3. Read Psalm 11:7 and Isaiah 52:8. Why is the promise of seeing God in Revelation 22:4 important? What does this reveal about God's desire to be with you without anything standing in the way?

4. Read Revelation 22:6–11. Why do you think John is once again tempted to worship an angel? What does this reveal about temptation to worship something other than God in your life?

5. Read Revelation 22:12–17 and Revelation 1:1–8. What parallels do you see between these passages? How do these form the perfect bookends of hope?

When Jesus delivers the Sermon on the Mount, he begins with beatitudes, or blessings, such as "Blessed are the pure in heart, for they will see God" (Matthew 5:8). Throughout the book of Revelation, beatitudes, or blessings, are spoken to those who follow Jesus faithfully.

6. Look up the following passages and fill in the chart below.

SCRIPTURE	BEATITUDE OR BLESSING	WHAT IS THIS PASSAGE CALLING YOU TO DO PERSONALLY?
Revelation **1:3**		
Revelation **14:13**		
Revelation **16:15**		
Revelation **19:9**		
Revelation **20:6**		
Revelation **22:7**		
Revelation **22:14**		

7. Read Revelation 22:18–21. Revelation opens with a blessing and closes with a curse. How is the warning in verses 18–19 actually a gift to us?

8. What are you most looking forward to with Christ's second coming?

DAY 3
YOUR BEAUTIFUL WORD

Review your notes and responses throughout this study guide. Place a star by those that stand out to you. Then respond to the following questions.

1. What's one thing you never knew about Revelation that you know now? How has that knowledge impacted you?

2. What are three of the most important truths you learned from studying Revelation?

3. After reviewing the six Beautiful Word coloring pages, which one stands out to you the most? Why?

4. What's one practical application from the study that you've put into practice? What's one practical application from the study that you still need to do?

5. What changes have you noticed in your attitudes, actions, and behaviors as a result of studying Revelation?

6. How are you treating or responding to others differently as a result of this study?

7. How are you walking in the extravagant hope of Jesus every day as a result of this study?

As you reflect on your personal study of Revelation 21:5–22, what are the beautiful words that the Holy Spirit has been highlighting to you through this time? Write or draw them in the space below.

SESSION 1

"I AM THE **ALPHA** AND THE **OMEGA**," SAYS THE LORD GOD, "WHO **IS**, AND WHO **WAS**, AND WHO **IS TO COME**, THE ALMIGHTY."

Revelation 1:8

SESSION 2

"YOU ARE **WORTHY**, OUR LORD AND GOD, TO RECEIVE **GLORY** AND **HONOR** AND **POWER**, FOR YOU CREATED ALL THINGS, AND BY YOUR WILL THEY WERE CREATED, AND HAVE THEIR BEING."

Revelation 4:11

SESSION 3

"**SALVATION BELONGS** TO OUR **GOD**, WHO SITS ON THE **THRONE**, AND TO THE **LAMB**."

Revelation 7:9

SCRIPTURE MEMORY CARDS

SESSION 4

"BUT HE THE ENEMY WAS NOT STRONG ENOUGH, AND THEY LOST THEIR PLACE IN HEAVEN."

Revelation 12:8

SESSION 5

"I SAW HEAVEN STANDING OPEN AND THERE BEFORE ME WAS A WHITE HORSE, WHOSE RIDER IS CALLED FAITHFUL AND TRUE. WITH JUSTICE HE JUDGES AND WAGES WAR."

Revelation 19:11

SESSION 6

"HE WILL WIPE EVERY TEAR FROM THEIR EYES. THERE WILL BE NO MORE DEATH OR MOURNING OR CRYING OR PAIN, FOR THE OLD ORDER OF THINGS HAS PASSED AWAY."

Revelation 21:4

ABOUT THE AUTHOR

Host of the popular podcast, *The Joycast*, **Margaret Feinberg** is a popular Bible teacher and speaker at churches and leading conferences. Her books, including *Fight Back With Joy, Taste and See: Discovering God Among Butchers, Bakers and Fresh Food Makers,* and their corresponding Bible studies, have sold over one million copies and received critical acclaim and extensive national media coverage from the Associated Press, *USA Today*, and more.

She was recently named one of 50 women most shaping culture and the church today by *Christianity Today.* Margaret lives in Utah with her husband, Leif, and their superpup, Zoom. She believes some of the best days are spent around a table with amazing food and friends.

Join her on Instagram and Facebook @mafeinberg.

Discover the Beauty of God's Word

The Beautiful Word™ Bible Study Series helps you connect God's Word to your daily life through vibrant video teaching, group discussion, and deep personal study that includes verse-by-verse reading, Scripture memory, coloring pages, and encouragement to receive your own beautiful Word from God.

In each study, a central theme—a beautiful word—threads throughout the book, helping you connect and apply each book of the Bible to your daily life today, and forever.

IN THIS SERIES:

GALATIANS — Jada Edwards — Available Now

REVELATION — Margaret Feinberg — Available Now

EPHESIANS — Lori Wilhite — Summer of 2021

| Study Guide 9780310115410 | DVD 9780310115434 | Study Guide 9780310122388 | DVD 9780310122401 | Study Guide 9780310130949 | DVD 9780310130963 |

Beautiful Word™ Bibles and Bible Journals are also available wherever books are sold.

BIBLE STUDY
SOURCE
for women
powered by ChurchSource

Connecting you with the best in

BIBLE STUDY RESOURCES

from many of the world's

MOST TRUSTED BIBLE TEACHERS

JENNIE
ALLEN

JADA
EDWARDS

MARGARET
FEINBERG

CHRYSTAL
EVANS HURST

Providing

**WOMEN'S MINISTRY AND
SMALL GROUP LEADERS**

with the **INSPIRATION, ENCOURAGEMENT,
AND RESOURCES** to grow your ministry

powered by ChurchSource

join our
COMMUNITY

FIND THE *perfect* BIBLE STUDY
for you and your group in 5 MINUTES *or* LESS!

Find the right study for your women's group
by answering four easy questions:

1. WHAT TYPE OF STUDY DO YOU WANT TO DO?
- *Book of the Bible:* Dive deep into the study of a Bible character, or go through a complete book of the Bible systematically, or add tools to your Bible study methods toolkit.
- *Topical Issues:* Have a need in a specific area of life? Study the Scriptures that pertain to that need. Topics include prayer, joy, purpose, balance, identity in Christ, and more.

2. WHAT LEVEL OF TIME COMMITMENT BETWEEN SESSIONS WOULD YOU LIKE?
- *None:* No personal homework
- *Minimal:* Less than 30 minutes of homework
- *Moderate:* 30 minutes to one hour of homework
- *Substantial:* An hour or more of homework

3. WHAT IS YOUR GROUP'S BIBLE KNOWLEDGE?
- *Beginner:* Group is comprised mostly of women who are new to the Bible or who don't feel confident in their Bible knowledge.
- *Intermediate:* Group has some experience with studying the Bible, and they have some familiarity with the stories in the Bible.
- *Advanced:* Group is comfortable with the Bible, and can handle the challenge of searching the Scriptures for themselves.

4. WHAT FORMAT DO YOU PREFER?
- *Print and Video:* Watch a Bible teacher on video, followed by a facilitated discussion.
- *Print Only:* Have the group leader give a short talk and lead a discussion of a study guide or a book.

Get Started! Plug your answers into the **Bible Study Finder**, and discover the studies that best fit your group!

Check out the Bible Study Finder at:
BibleStudySourceForWomen.com